Thoughts on Building

Thoughts on Building

Edited by Markus Breitschmid

Corporis
Publisher for Architecture, Art, and Photography

Thoughts on Building
Markus Breitschmid, Editor

Corporis
Publisher for Architecture, Art, and Photography
Zurich
www.corporis.ch

Content

On Art and Nature

Architecture is an art of pure invention, because there are no finished prototypes in nature for the forms of architecture; they are free creations of human fantasy and reason.

Gottfried Semper

Art does not belong to nature but solely to men.

Friedrich Nietzsche

The organic product of nature will therefore not necessarily be *beautiful,* and if it is beautiful, its beauty, because the necessity for its existence cannot be thought as existing in nature, will appear as utterly arbitrary. ... This clarifies what ought to be thought of imitation of nature as the principle of art, since by no means does nature – which is only accidentally beautiful – prescribe the rule for art. Instead, that which art produces in its perfection is the principle and norm for the judgment of natural beauty.

Friedrich Wilhelm Joseph von Schelling

Matter as such cannot be the expression of an Idea. For, as we found in the first book, it is throughout nothing but causality: Its being consists in its casual action. But causality is a form of the principle of sufficient reason; knowledge of the Idea, on the other hand, absolutely excludes the constant of that principle. We also found, in the second book, that matter is the common substratum of all particular phenomena of the Ideas, and consequently is the connecting link between the Idea and the phenomenon, or the particular thing. Accordingly for both of these reasons it is impossible that matter can itself express any Idea.

Arthur Schopenhauer

Hence the purposiveness in products of the fine arts must not seem purposeful, although they are purposeful; i.e. fine art must be able to be considered as nature, our consciousness of it as art notwithstanding. A product of art appears to be nature when it agrees exactly with the rules according to which alone the product can become what it is intended to be, yet without displaying the embarrassment of academic form, i.e. without indicating that the rule had guided the artist and restrained his mental powers.

Immanuel Kant

We will cease to want to see nature through art; rather, we will submit to art so it teaches us to see nature.

Konrad Fiedler

The artist is in need of the unfaithfulness of his memory in order to not to copy nature but to reshape it.

Friedrich Nietzsche

16

Genius is the talent (natural endowment) that gives the rule to art. Be-
cause talent as an innate productive ability of the artist belongs itself
to nature, one could also say: Genius is the innate, mental aptitude
(ingenium) through which nature gives the rule to art.

Immanuel Kant

The postulated intuition should comprehend what exists separated in the appearance of freedom and in the intuition of the product of nature, namely, identity of conscious and unconscious in the ego and consciousness of this identity. The product of this intuition will thus be contiguous on the one side with the product of nature and on the other side with the product of freedom, and it will have to unite within itself the characteristics of both. If we know the product of intuition, then we also know the intuition itself. We therefore need only deduce the product in order to deduce the intuition. [...] The postulated product is none other than the product of genius, or, since genius is possible only in art, the product of art.

Friedrich Wilhelm Joseph von Schelling

On Art and Truth

The absolute cannot be a thing, and whatever cannot be an object necessarily escapes conceptualization.

Friedrich Wilhelm Joseph von Schelling

Yet the *appearance* itself is essential for the *essence,* truth would not be, if it did not shine and appear.

Georg Wilhelm Friedrich Hegel

Architecture does not signify; rather, it allows something to be fully present.

Unknown

With art and philosophy man is building an "immortality of the intellect".

Friedrich Nietzsche

The objectivity of the intellectual intuition that is generally accepted and by no means deniable is art itself. Because the aesthetic intuition is precisely the intellectual intuition gone objective. Only the artwork reflects for me what is not reflected in anything else, namely that absolute identity that had already divided itself in the self. What philosophers regard as already divided in the first act of consciousness is being reflected through the miracle of art while it is inaccessible for every other intuition.

Friedrich Wilhelm Joseph von Schelling

All art repels references of how it is made. It likes to appear as improvisation, as a sudden miracle (like the temple as a work of God or the sculpture as an enchantment of a soul into stone).

Friedrich Nietzsche

Art can be approached in no other way other than through itself.

Konrad Fiedler

Man is a form-creating and rhythm-creating creature; there is nothing in which he is not better practiced and there is nothing that seems to give him more joy than the inventing of forms.

Friedrich Nietzsche

A building, a Greek temple, does not represent anything. It merely stands there in the midst of the rugged mountain valley.

Martin Heidegger

We search everywhere for the absolute, but we always only find things.

Novalis (Georg Philipp Friedrich Freiherr von Hardenberg)

If men had never built houses for gods, architecture would still be in its infancy. Tasks self-imposed on the strength of false assumptions (e.g., soul separable from body) have given rise to the highest forms of culture. "Truth" lack the power to motivate in this way.

Friedrich Nietzsche

On Beauty and the Beautiful

The *beautiful* is that which, without any concept, pleases universally.

Immanuel Kant

Beauty is the form of purposiveness in an object, insofar as it is perceived without the representation of a purpose.

Immanuel Kant

But what brings us pleasure without actually being useful we call beautiful ... I have to take pleasure in a beautiful object purely for its own sake; to this end the lack of an exterior purpose must be replaced by an inner purpose; the object must be something perfect in itself.

Karl Philipp Moritz

By an aesthetic idea I mean that representation of imagination that incites much thought, yet without any thought, i.e. concept ever being adequate to it and that can therefore not be reached and rendered comprehensible by any language.

Immanuel Kant

I understand a system to be the unity of the manifold insights under one idea. This is the concept of reason in the form of a totality, insofar as it determines *a priori* the scope of the manifold as well as the position of the parts in respect to each other.

Immanuel Kant

Such is the case with every true work of art inasmuch as every one, as if an infinity of purposes were contained in it, is capable of infinite interpretation, and one can never say whether this infinity had its cause in the artist or lies merely in the work of art.

Friedrich Wilhelm Joseph von Schelling

In order to distinguish whether anything is beautiful or not, we refer to the presentation, not by the understanding to the object for cognition but by the imagination (perhaps in conjunction with the understanding) to the subject and its feeling of pleasure or pain. The judgment of taste is therefore not a judgment of cognition, and is consequently not logical but aesthetical, by which we understand that whose determining ground can be no other than subjective.

Immanuel Kant

42

There are two types of beauty: free beauty (pulchritudo vaga) or merely adherent beauty (pulrichtudo adherens). The first does not presuppose any concept of what the object is meant to be; the second presupposes such concept and the perfection of the object according to it. The types of the former are called (independent existing) beauties of this or that object; the other, as adherent to a concept, is attributed to objects that are classed under the concept of a particular purpose.

Immanuel Kant

We called the beautiful the Idea of the beautiful. This means that the beautiful itself must be grasped as Idea, in particular as Idea in a determinate form, i.e. as Ideal. Now the Idea as such is nothing but the Concept, the real existence of the Concept, and the unity of the two. For the concept as such is not yet the Idea, although 'Concept' and 'Idea' are often used without being distinguished. But it is only when it is present in its real existence and placed in unity therewith that the Concept is the Idea.

Georg Wilhelm Friedrich Hegel

In a truly beautiful work of art the content should do nothing, the form everything, because form alone affects man in his entirety, while content affects only individual faculties.

Friedrich Schiller

Among all faculties and talents taste, because its judgment is not determined by concepts and regulations, is the one most in need of those examples that have received applause for the longest time in the course of culture so that it does not fall back into the rudeness of its earliest efforts and become crude again.

Immanuel Kant

On Artists and Architects

The artist is the origin of the work of art. The work of art is the origin of the artist. Neither is without the other.

Martin Heidegger

The price of being an artist is such that we consider as content what all non-artists identify as form. Therewith one belongs sure enough to a consorted world.

Friedrich Nietzsche

In great art, and we only talk about such art, the artist remains irrel-
evant in respect to the work, almost a self-destructing passage for the
production of the work.

Martin Heidegger

It is not the architectural achievement of earlier times that make their buildings appear so significant to us, but the circumstance that the antique temples, the Roman basilicas, and also the cathedrals of the Middle Ages were not the work of individual personalities but the creation of entire epochs. Who asks, when viewing such buildings, for names, and what would the accidental personality of their builders mean? These buildings are by their very nature totally impersonal. They are pure representatives of the will of the epoch. This is their significance. Only so could they become symbols of their time. The building art is always the spatially apprehended will of the epoch, nothing else … Questions of a general nature are of central interest.

Ludwig Mies van der Rohe

Le Corbusier

The actor, the mime, the dancer, the musician, the lyric poet, are closely akin; in their instincts they are ultimately one. But they have gradually specialized and separated from each other – to the point of mutual contradiction. The lyric poet longest remained at one with the musician; the actor with the dancer. The *architect* represents neither a Dionysian nor an Apollonian state: what impels him to art is the great act of will, the will that moves mountains, the ecstasy of the great will. The mightiest men have always lent inspiration to architects; the architect has always lived beneath the mental sway of power. In a building, pride, the defeat of gravity, the will to power must manifest themselves. Architecture is a kind of eloquence of power conveyed through forms: now persuasive, even cajoling; now starkly commanding. The supreme feeling of power and assurance is conveyed by that which possesses the *Grand Style*. The power that has nothing left to prove; which disdains to please; which is oblivious of any onlooker; which unconsciously thrives on the existence of opposition; which remains *self*-contained, fatalistic, a law of other laws: *such* power speaks for itself as the Grand Style.

Friedrich Nietzsche

For whom does an architect build? Might the multitude of diverse reflections, the repercussion in many psyches, be Nature's purpose? I think he builds for the next great architect. Every work of art seeks to procreate and casts about for receptive and procreative souls. Likewise the philosopher.

Friedrich Nietzsche

Man plays only when he is in the full sense of the word a man, and he is only wholly man when he is playing.

Friedrich Schiller

The artist must distance himself from the product or the creation, but only in order to be elevated to the creative force and to grasp it mentally. Through this he soars upward into the realm of pure concepts; he leaves the creation in order to regain it with thousand-fold interest and thereby to return to it. That spirit of nature that labors inside the object through form and gestalt as if through images the artist must imitate, and only insofar as he grasps it in his imitation does he achieve truth.

Friedrich Wilhelm Joseph von Schelling

I think one of the important evolutions is that we no longer feel com-
pulsively the need to argue, or to justify things on a kind of rational
level. We are much more willing to admit that certain things are com-
pletely instinctive and others are really intellectual.

Rem Koolhaas

Morale for architects. – One ought to remove the scaffolding once the building is constructed.

Friedrich Nietzsche

On Building Worlds

The work erects a world.

Martin Heidegger

In the work of art happens in an exemplary manner what we all do in existing: constant construction of world.

Hans-Georg Gadamer

The temple, through its existence, grants to the things their face and to man the perspective on himself.

Martin Heidegger

The ego, the individual mind, cannot create reality. Man is surrounded by a reality that he did not make, that he has to accept as an ultimate fact. But it is for him to interpret reality, to make it coherent, understandable, intelligible – and this task is performed in different ways in the various human activities, in religion and art, in science and philosophy. In all of them man proves to be not only the passive recipient of an external world; he is active and creative. But what he creates is not a new substantial thing; it is a representation, an objective description of the empirical world.

Ernst Cassirer

Architecture for the perceptive. There is and probably will be a need to perceive what our great cities lack above all: still, wide, extensive places for reflection; places with tall, spacious, lengthy colonnades for inclement or unduly sunny weather where no traffic noise or street cries can penetrate, and where a finer sensibility would forbid even a priest to pray aloud: buildings and places that express as a whole the sublimity of stepping aside to take thought for oneself. The time is past when the Church possessed the monopoly of reflection; when the *vita contemplativa* primarily had to be a *vita religiosa;* and yet that is the idea expressed in everything the Church has built. I do not know how we could ever content ourselves with its buildings, even stripped of their ecclesiastical function; they speak far too emotive and too con-strained a language, as the houses of God and as the showplaces of intercourse with another world, for us as godless people to think our thoughts in them. We want to have *ourselves* translated into stones and plants; we want to have *ourselves* to stroll in, when we take a turn in those porticoes and gardens.

Friedrich Nietzsche

It is no representation that would allow us to learn how the god looks, instead it is a work that lets the god himself be present and therefore *is* the god himself.

Martin Heidegger

World is never an object that stands before us and can be contem-
plated. World is always that immaterial being that governs us as long
as the paths of birth and death, blessing and spell hold us outside
ourselves into Being. Where the essential decisions of our history are
made, are accepted and abandoned by us, mistaken and newly in-
quired about, there the world worlds [da weltet die Welt].

Martin Heidegger

The work of art transforms our fleeting experience into the stable and lasting form of an independent and internally coherent creation. It does so in such a way that we go beyond ourselves by penetrating deeper into the work. That "something can be held in our hesitant stay" – this is what art has always been and still is today.

Hans-Georg Gadamer

... poetically dwells man upon this earth.

Friedrich Hölderlin

What remains of the undertakings of man is not what is useful but what moves and arouses us.

Le Corbusier

Where has God gone? What have we done? Have we swallowed up the ocean? What sponge have we used to obliterate the whole horizon around us? How have we contrived to erase the fixed, eternal line to which in the past all lines and measurements were related, by which all life's architects did their building, and without which there seemed to be no perspective, no order, no architecture? Are we ourselves still on our feet? Are we not constantly *tumbling?* Hurtling down, back, sideways, in all directions? Have we not wrapped infinite space around us like cloak of icy air? And lost all gravity, because for us there is no up or down? And if we still live and enjoy light, seemingly as we always have, do we not do so – as it were – by the twinkle of stars that have ceased to shine? ... God is dead! *And we have killed him!* This feeling, of having killed the mightiest and holiest thing the world ever possessed, has yet to dawn upon mankind: it is a monstrous, *new* feeling! How does the murderer of all murderers console himself how will he cleanse himself!

Friedrich Nietzsche

Building art is not the object of clever speculation, it is in reality only understandable as a life process, it is an expression of man's ability to assert him and master his surroundings.

Ludwig Mies van der Rohe

On Art and Architecture

Architecture is inhabited sculpture.

Constantin Brancusi

The current discussion about not making architecture as objects is misguided. Objects are the only things in architecture that are worth something.

Valerio Olgiati

100 deep solitaires form together the city of Venice - that is its magic.
An image for men of the future.

Friedrich Nietzsche

Genoa. I have spent a good while looking at this city, its villas and pleasure gardens, and the wide expanse of its inhabited heights and slopes; and at length I am compelled to say that I see *faces* from past generations: this landscape is strewn with the portraits of bold and autocratic men. They lived, and they wanted to live on - so they tell me through their houses, built and decorated for centuries and not for the fleeting hour. They meant well by life, ill though they may often have treated each other. I constantly see the man for whom the house was built, turning his gaze upon on all that is built around him, near and far, and on the city, the sea, and the distant mountains; and with that gaze exerting power of conquest: he means to bring all this into *his* plan - and, by thus incorporating it, to possess it. This whole landscape teems with this gloriously insatiable egotism of possession and acquisition. Just as these individuals knew no boundaries in distant lands; and just as, in their thirst for novelty, they set a new world alongside the old, so at home every man took issue with every other and devised a way to express his own superiority, and to interpose an infinity of his own between himself and his neighbor. Each of them has conquered his native soil anew, for himself, by imposing his architectural conceptions upon it and remaking it, as it were, for the sake of the view from his house ... Here, at every turn, you find a man who loathes the tedium of laws and neighbors, and who measures everything existing with a jealous glance: he would like to shape everything once more with a magic slyness of fantasy, at the very least to redo everything in his imagination, to put his hand on it and his ideas in it, even if it is just for a moment of a sunny afternoon in which his insatiable and melancholic soul feels content, and his eye meets only things of his own and nothing strange.

Friedrich Nietzsche

Caspar David Friedrich does not recognize the unconditional demand of Cammerherr von Ramdohr that a landscape ought to represent multiple planes. Friedrich does also not recognize that the painterly is only what comes from the highest possible variation of form and color; and that next to a straight line ought to stand one that is crooked. Also not recognized is that one line suggests jumping joy, while the other suggests slowness and sadness ... briefly expressed, Friedrich is an outspoken opponent of the so-called contrast. Friedrich finds the concept to search for expression through opposites as a folly (only crude and plain people articulate themselves through opposites). It is my opinion that very true work of art has to communicate a defined idea. The mind of the spectator has to be moved either towards joy or towards sorrow, towards solemnity or towards happiness but not towards all characteristics unified into a jumble of impressions. The work of art ought to be only one thing; and that will ought to penetrate the entire work of art in such manner that every single part of the work of art possesses the structure of the whole.

Caspar David Friedrich

The haze of the carnival candles is the true atmosphere of art.

Gottfried Semper

Painting has nothing to do with thinking, because in painting thinking is painting. Thinking is language – record-keeping – and has to take place before and after. Einstein did not think when he was calculating: he calculated – producing the next equation in relation to the one that went before – just as in painting one form is a response to another, and so on.

Gerhard Richter

A building is a building. It cannot be read like a book; it doesn't have any credits, subtitles or labels like pictures in a gallery. In that sense, we are absolutely anti-representational. The strength of our buildings in the immediate, visceral impact they have on a visitor.

Jacques Herzog

Of the ideas which architecture seeks to bring to distinct perception, its one constant theme is support and burden, and its fundamental law is that no burden be without sufficient support, and no support without a suitable burden; consequently that the relation of these two shall be exactly the fitting one. The purest example of the carrying out of this theme is the column and entablature. Therefore the order or columnar arrangement has become, as it were, the thorough bass of the whole of architecture.

Arthur Schopenhauer

To construct in space is the aim and the end of architecture; but space is anti-spirit; it is pure extension, absolute and complete realization, while spirit is pure and continuous tension, the everlasting condition of becoming. Thus for modern thought, architecture really seems something too closely tied to the material and is quasi-extraneous and hostile to spirit. The character of architecture differentiates it substantially from all the other arts which we may call expressive, in that they express feelings or concrete ideas; architecture, on the contrary, succeeds in arousing particular feelings or states of mind by expressing only abstract ideas or, better expressed, simply by realizing these abstract ideas in material terms. The absence of an emotional content in architecture is one of he most salient features of its aesthetic, since it is due precisely to the absence that the gamut, so to speak, of the architecturally beautiful is so limited, excluding as it does many values of emotional nature. However, to the same absences also is due that sense of calm tranquility, of elevation, of solemnity, and of liberation which architecture succeeds in giving us and by which it attains a true symbolic representation of the transcendent world, free of passion and governed by unbreakable laws ... in which absolute ideas ... seem to be achieved in stone for eternity.

Salvatore Vitale

Only a very small part of architecture really belongs to art: the funeral stone and the memorial. Everything else, because it serves a purpose, should be excluded from the realm of art. Only when the great mis-understanding that art can be made serviceable has been overcome ... only then will we arrive at the architecture of our time.

Adolf Loos

The building art can only be unlocked from a spiritual center and can only be understood as a living process ... The building art is man's spatial dialogue with his environment and demonstrates how he asserts himself therein and how he masters it. For this reason, the building art is not merely a technical problem nor a problem of organization or economy. The building art is in reality always the spatial execution of spiritual decisions. It is bound to its times and manifests itself only in addressing vital tasks with the means of its times. Knowledge of the times, its tasks, and its means is the necessary precondition of work in the building art.

Ludwig Mies van der Rohe

One should not build if there is no time.

Friedrich Nietzsche

The anthology *Thoughts of Building* is not all-encompassing of all building nor is it taking a neutral position on the question of how building ought to be conceived. *Thoughts of Building* is a scaffolding for a theory of architecture.

Corporis
Publisher for Architecture, Art, and
Photography
Zurich
www. corporis.ch